MARLEGENDS

MARLEGENDS

Zephry

Copyright © 2019 by Zephry.

ISBN: Softcover 978-1-7960-0440-3
 eBook 978-1-7960-0439-7

All rights reserved. No part of this book may be reproduced or transmitted in any form or by any means, electronic or mechanical, including photocopying, recording, or by any information storage and retrieval system, without permission in writing from the copyright owner.

Any people depicted in stock imagery provided by Getty Images are models, and such images are being used for illustrative purposes only.
Certain stock imagery © Getty Images.

Print information available on the last page.

Rev. date: 06/27/2019

To order additional copies of this book, contact:
Xlibris
1-800-455-039
www.Xlibris.com.au
Orders@Xlibris.com.au
798723

All artworks are original and created by the author.

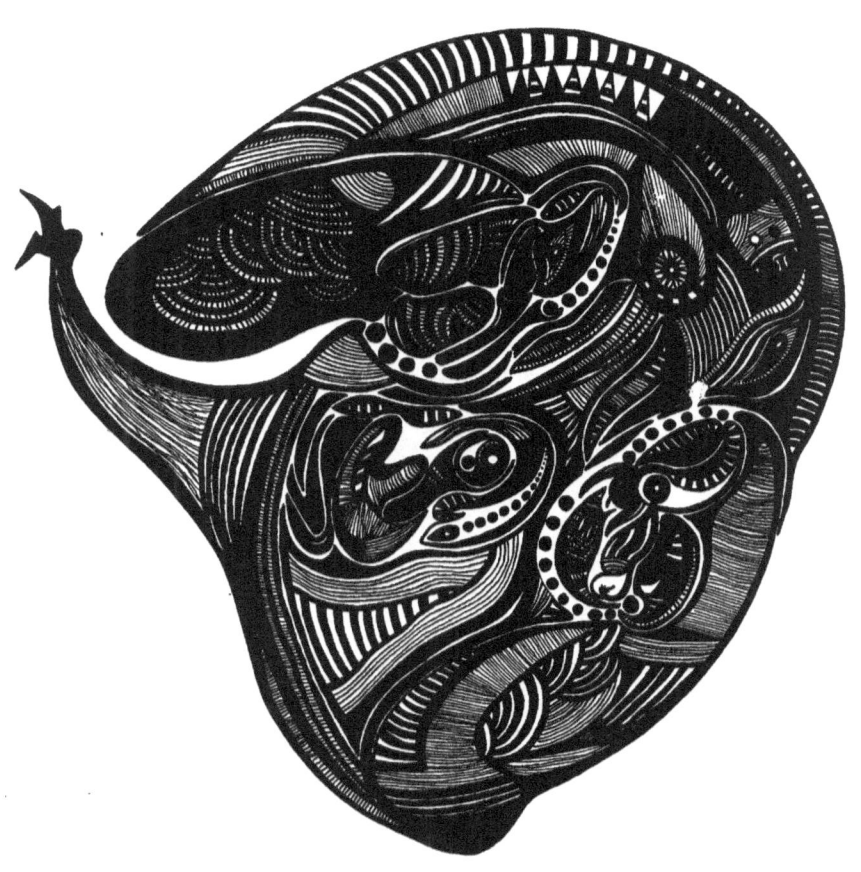

absorbing elders

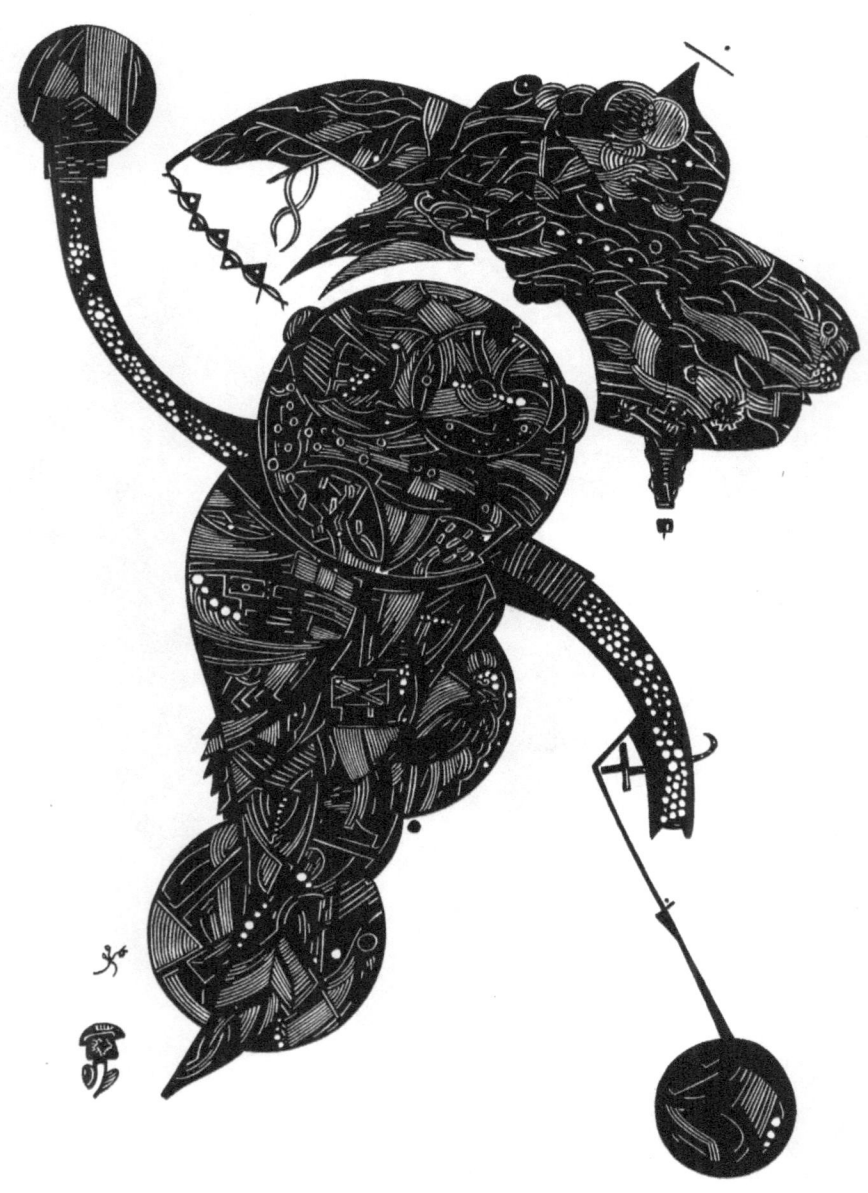

shhh muppet

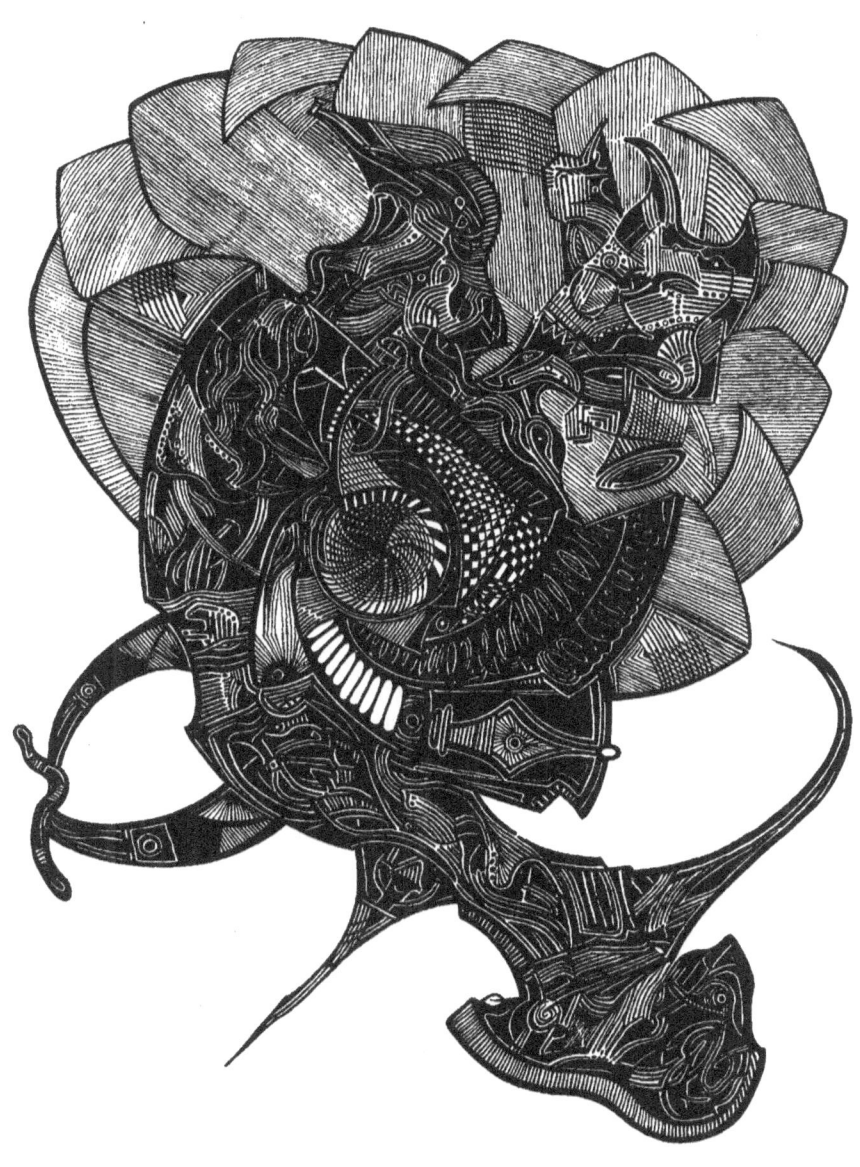

im not gonna let you outta worm

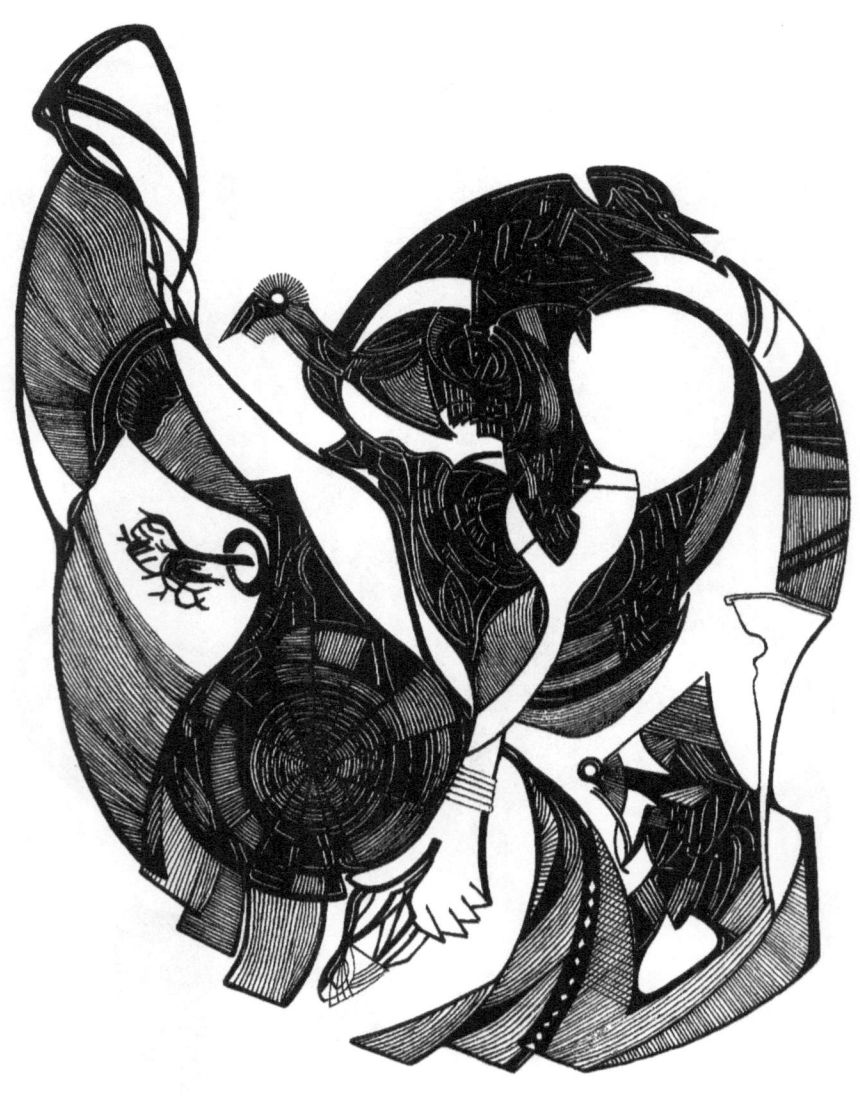

climb the ladder

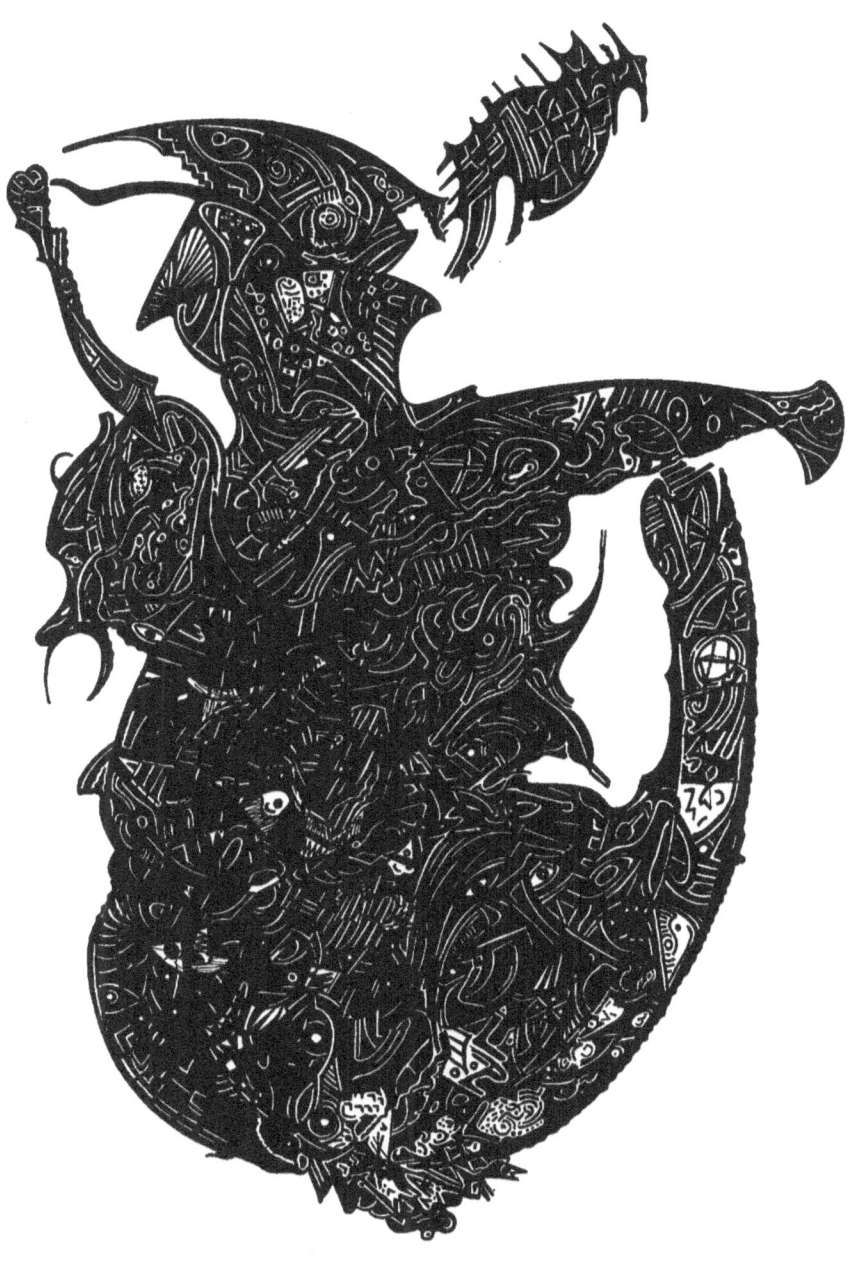

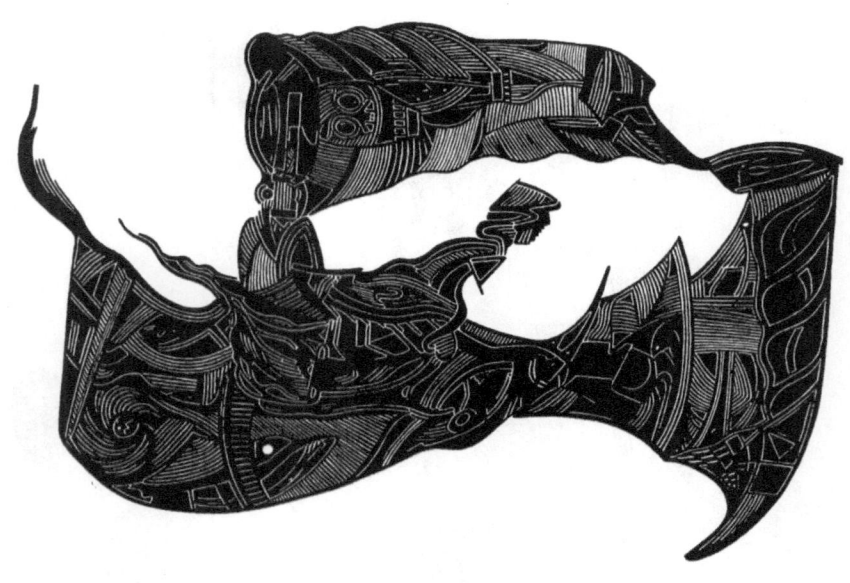
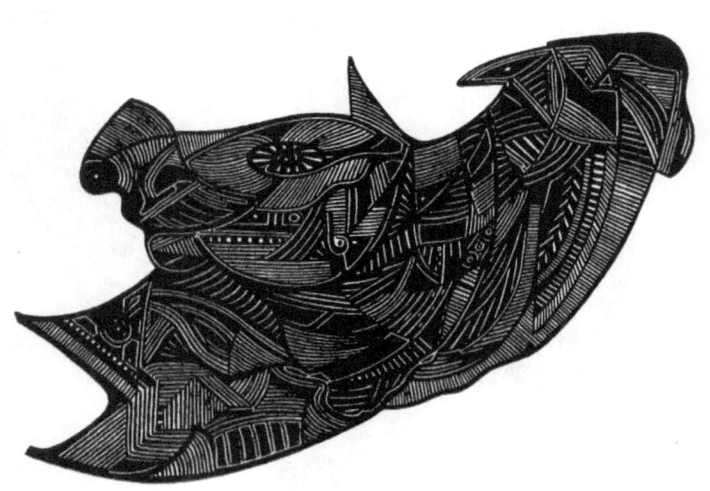

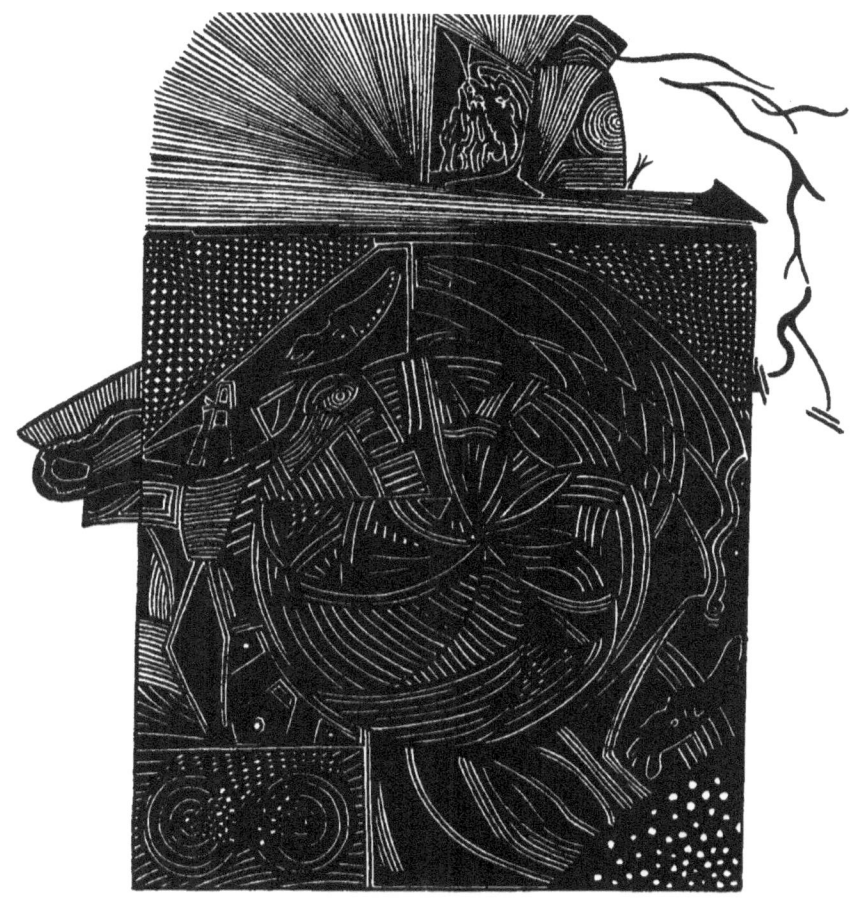

darkness is never alone

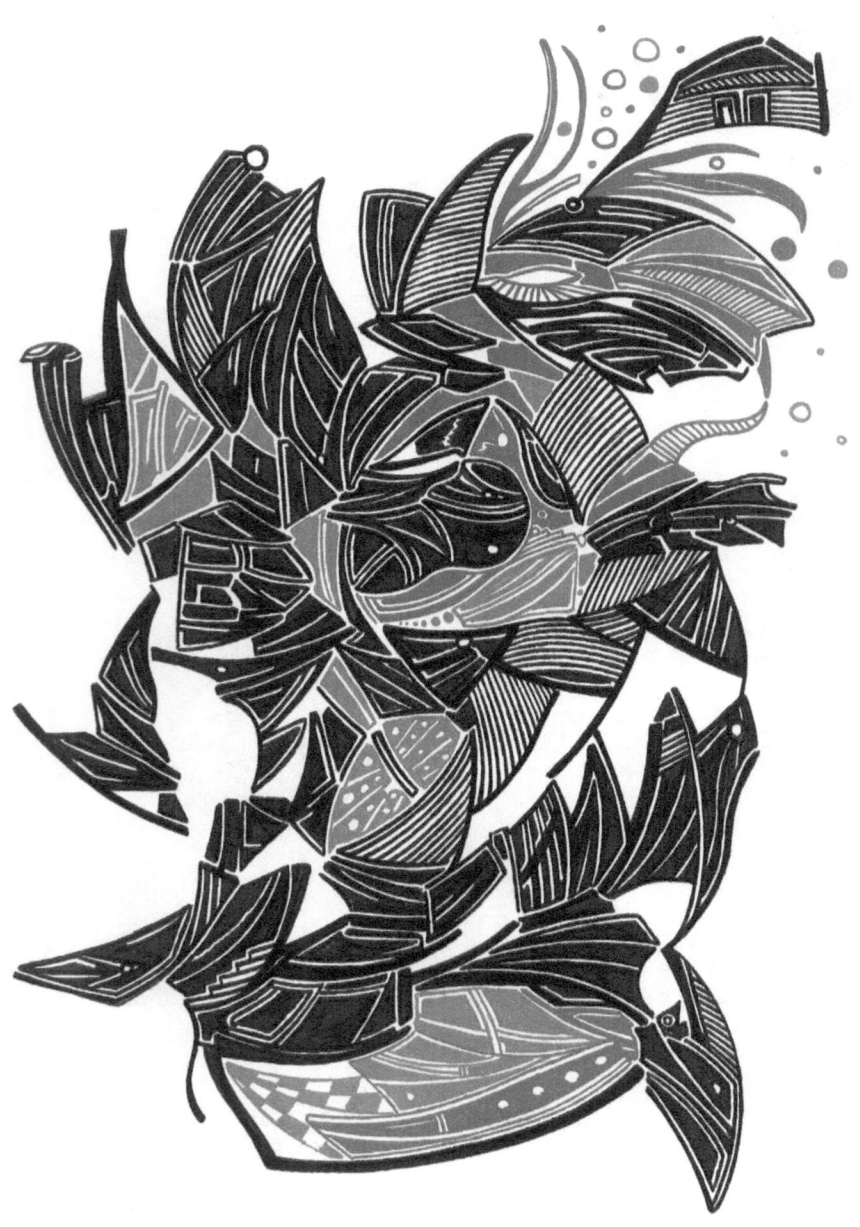

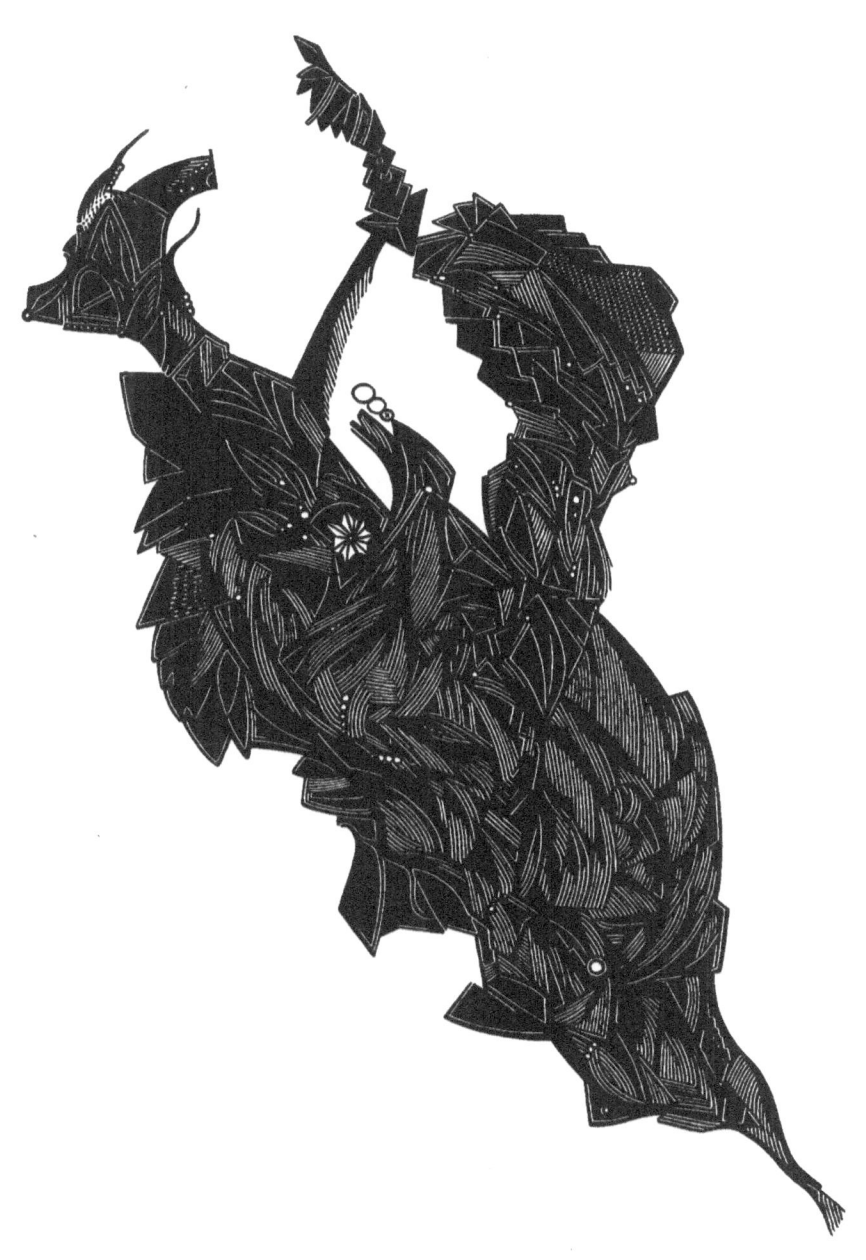

the religion of the now is cosmic

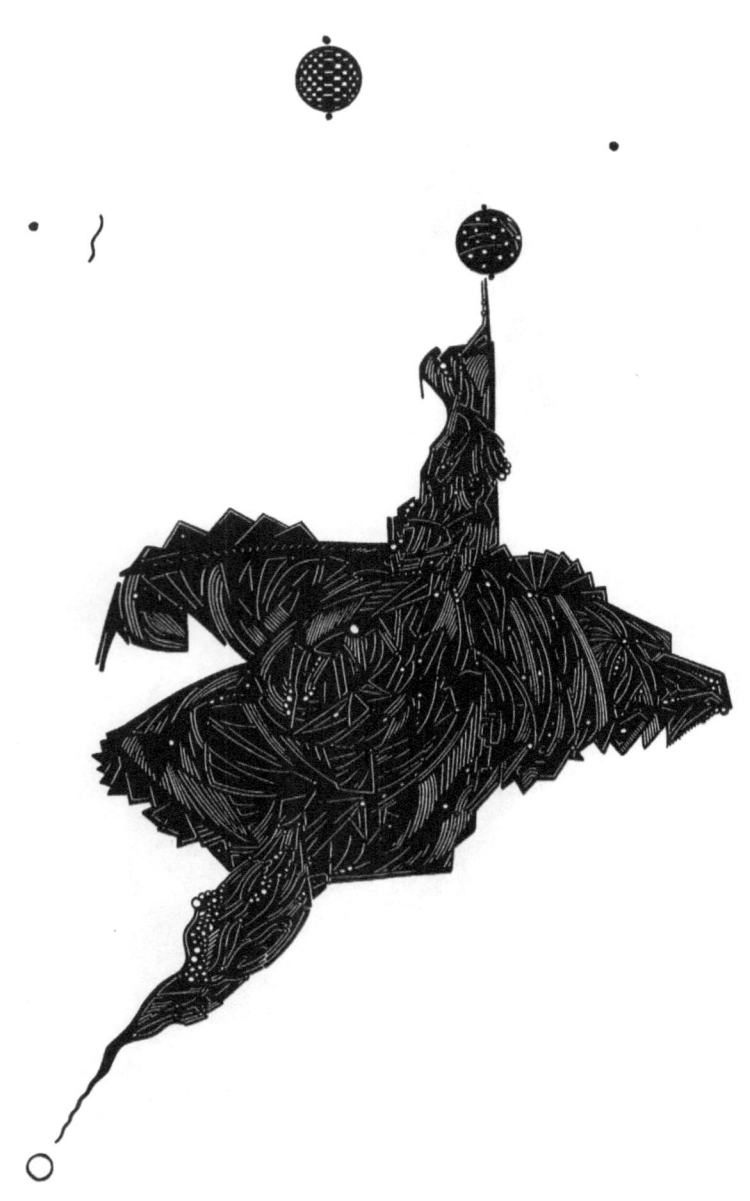

don't run away

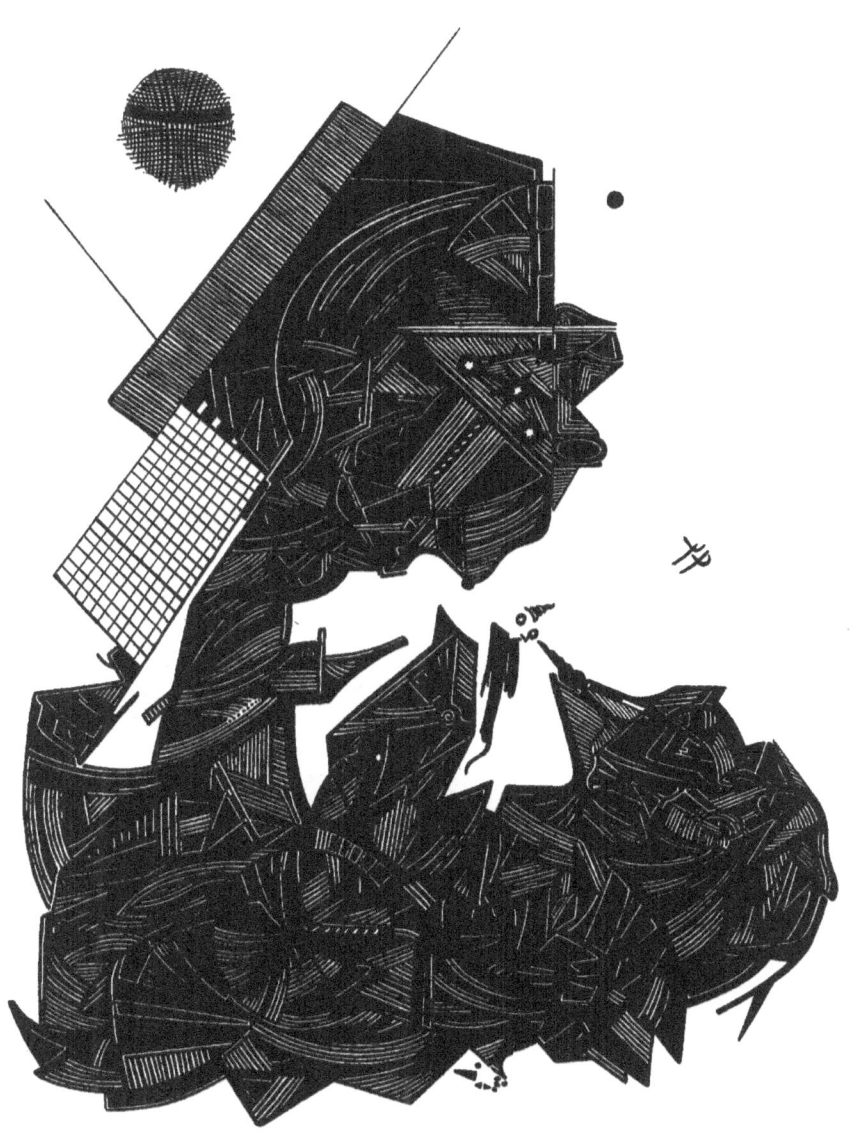

circular doors

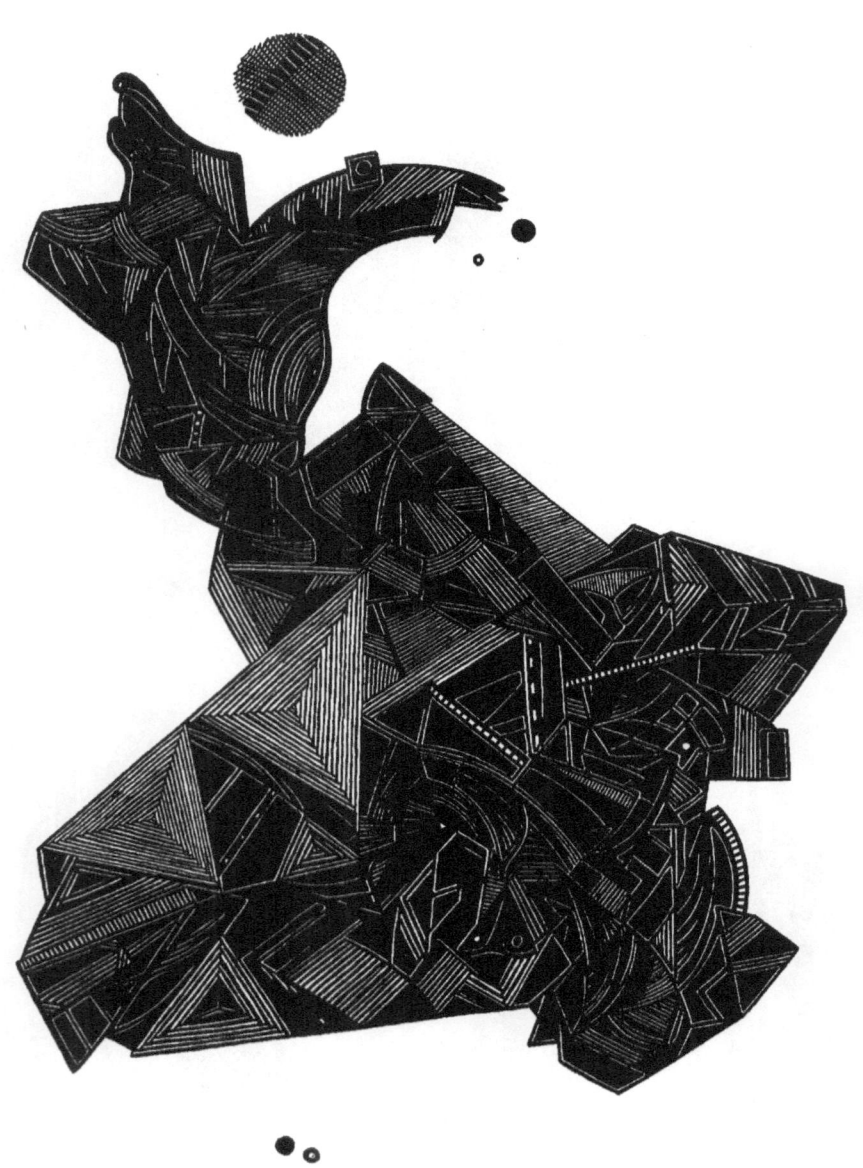

in order to find our first breath you exband

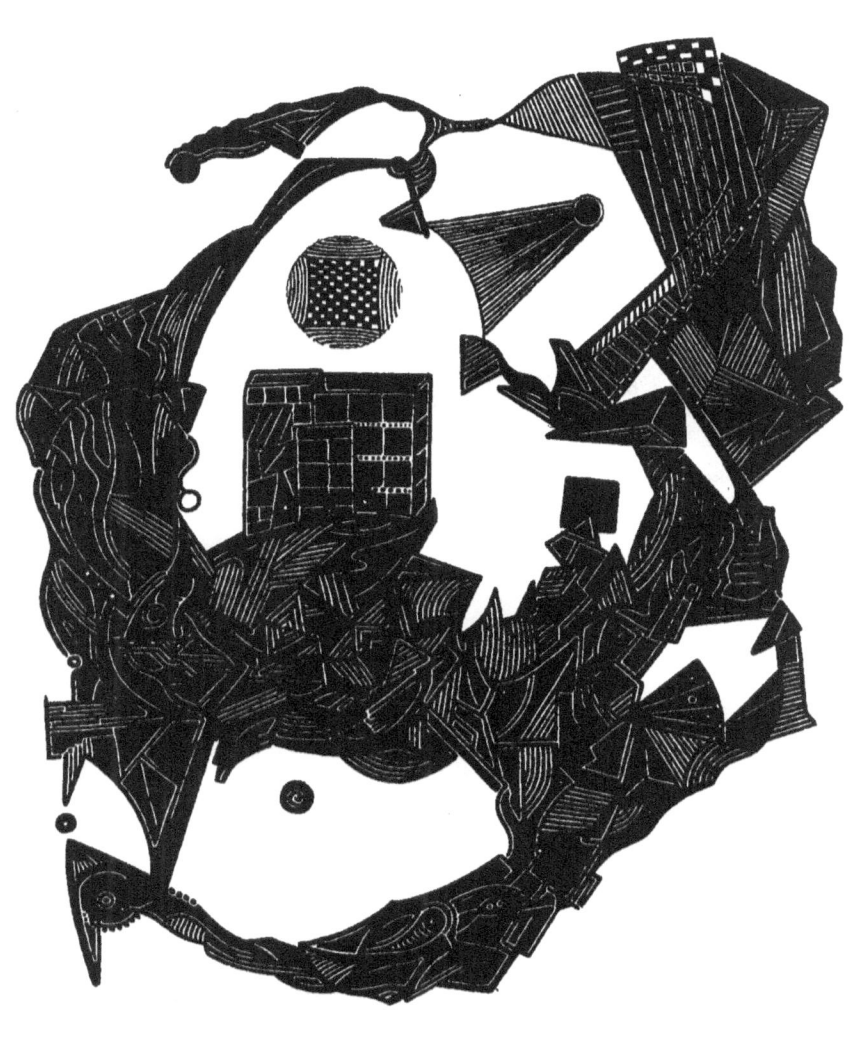

find your beat/flow

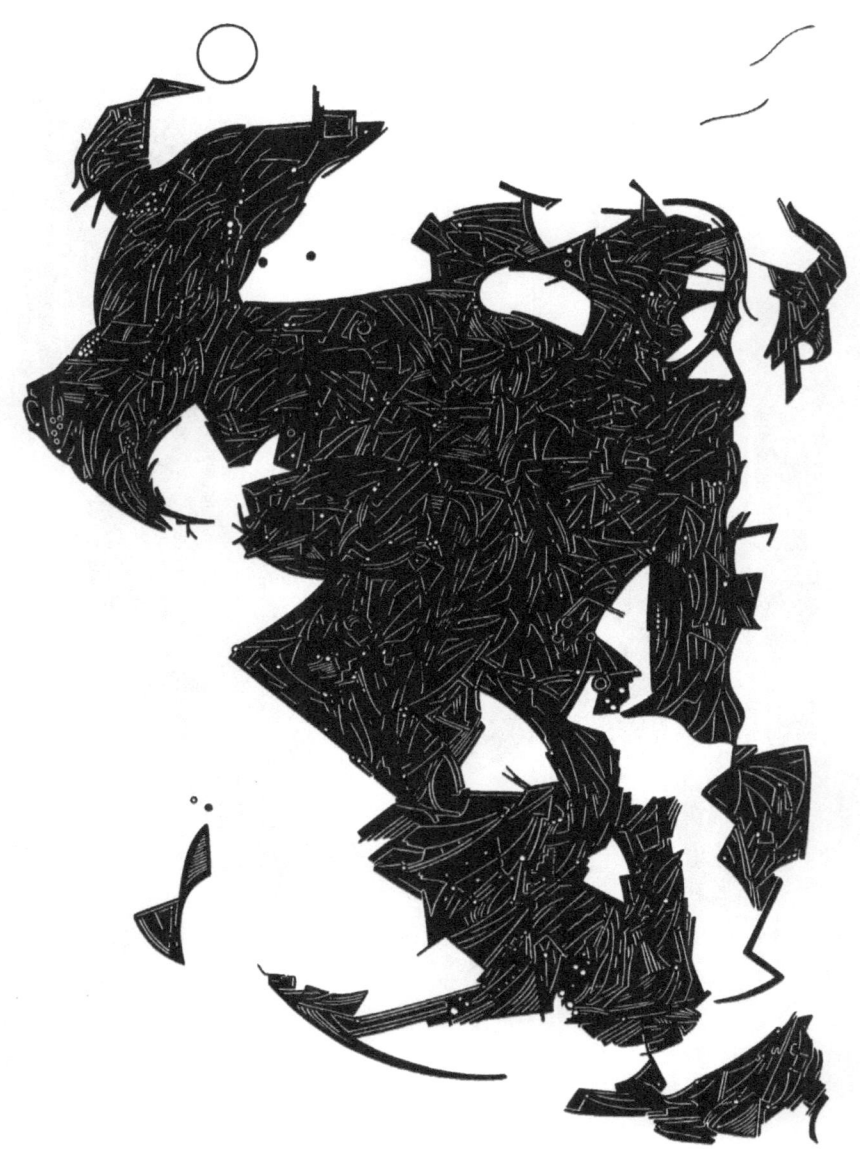

we haven't even been born yet

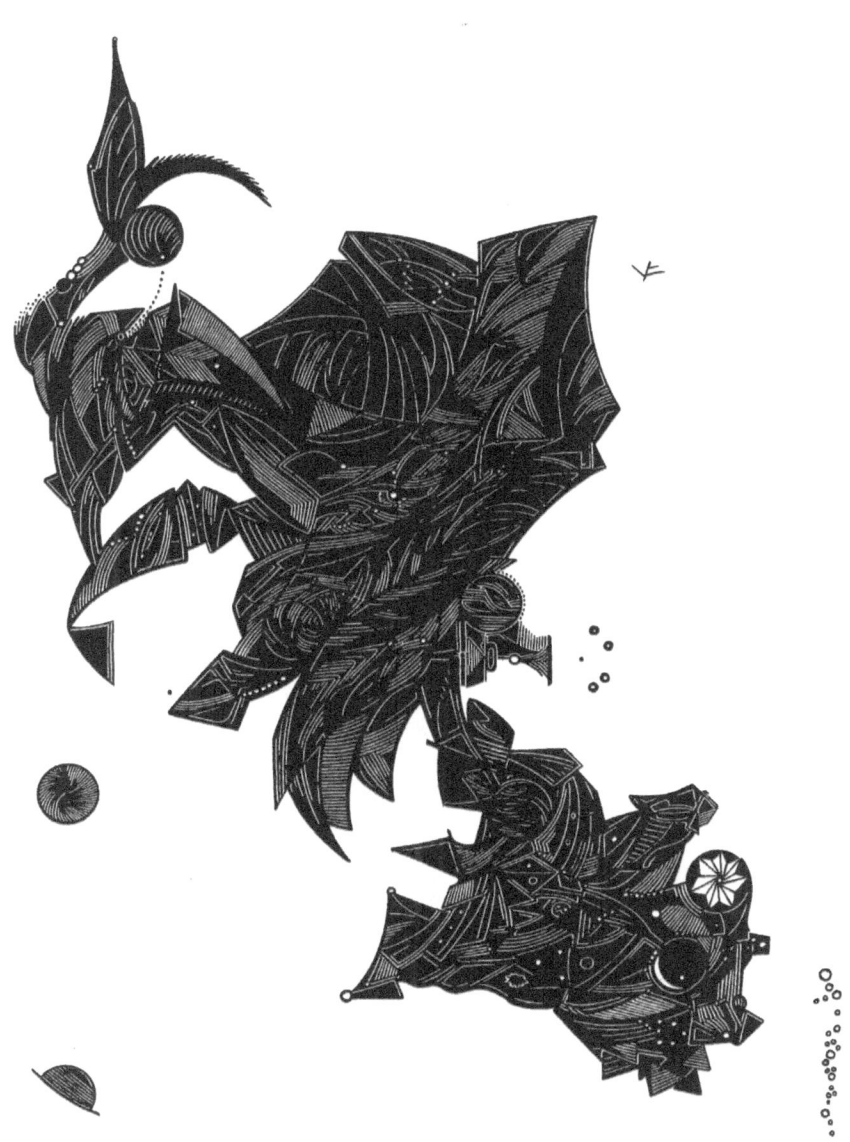

time is a current

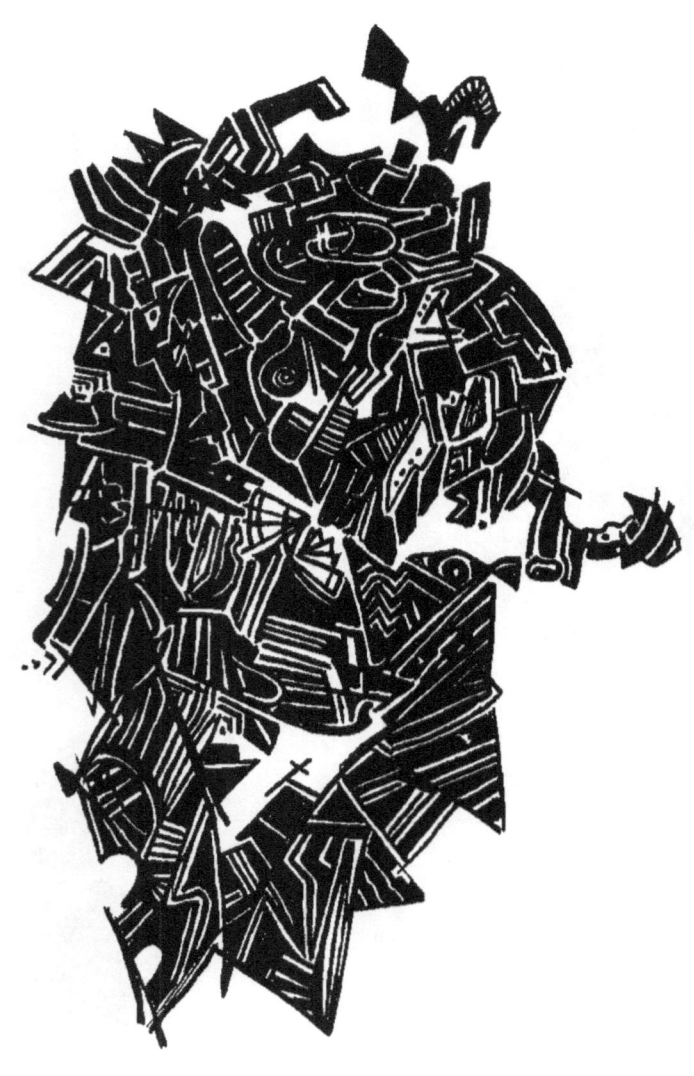

one track path

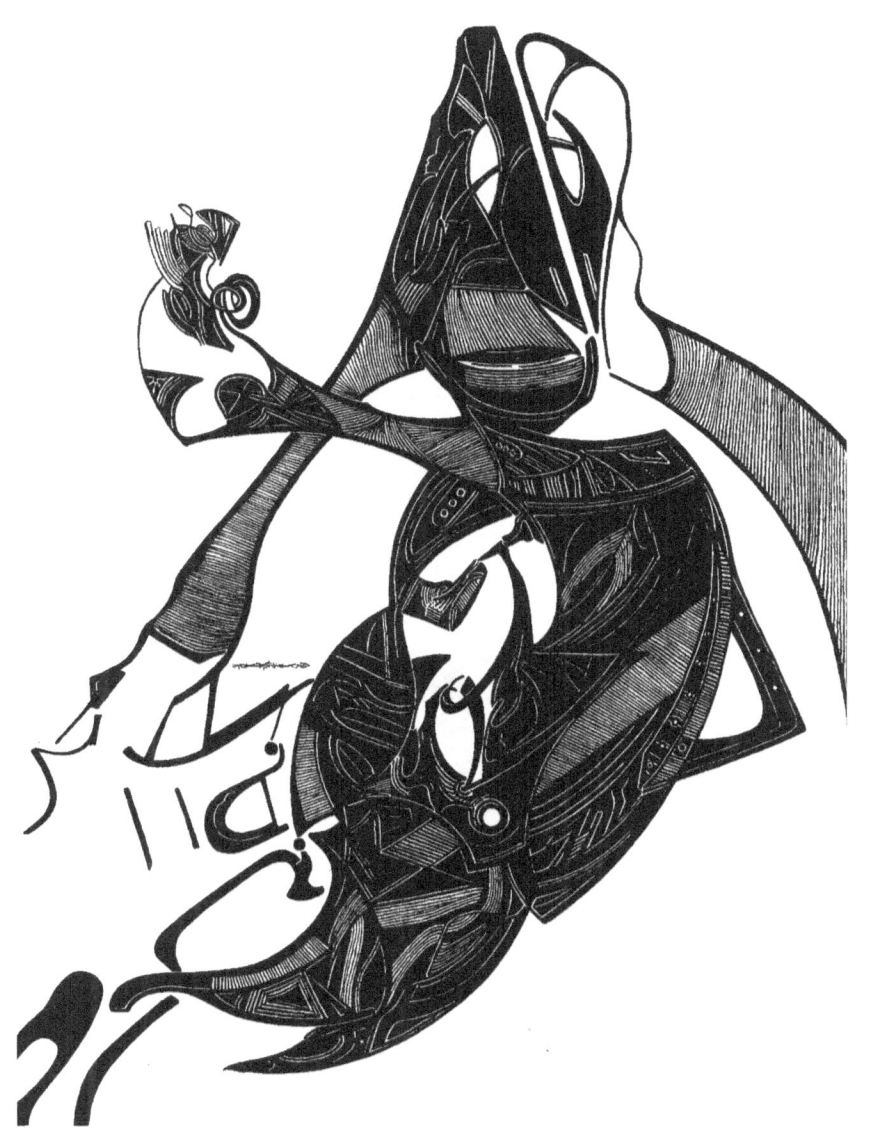

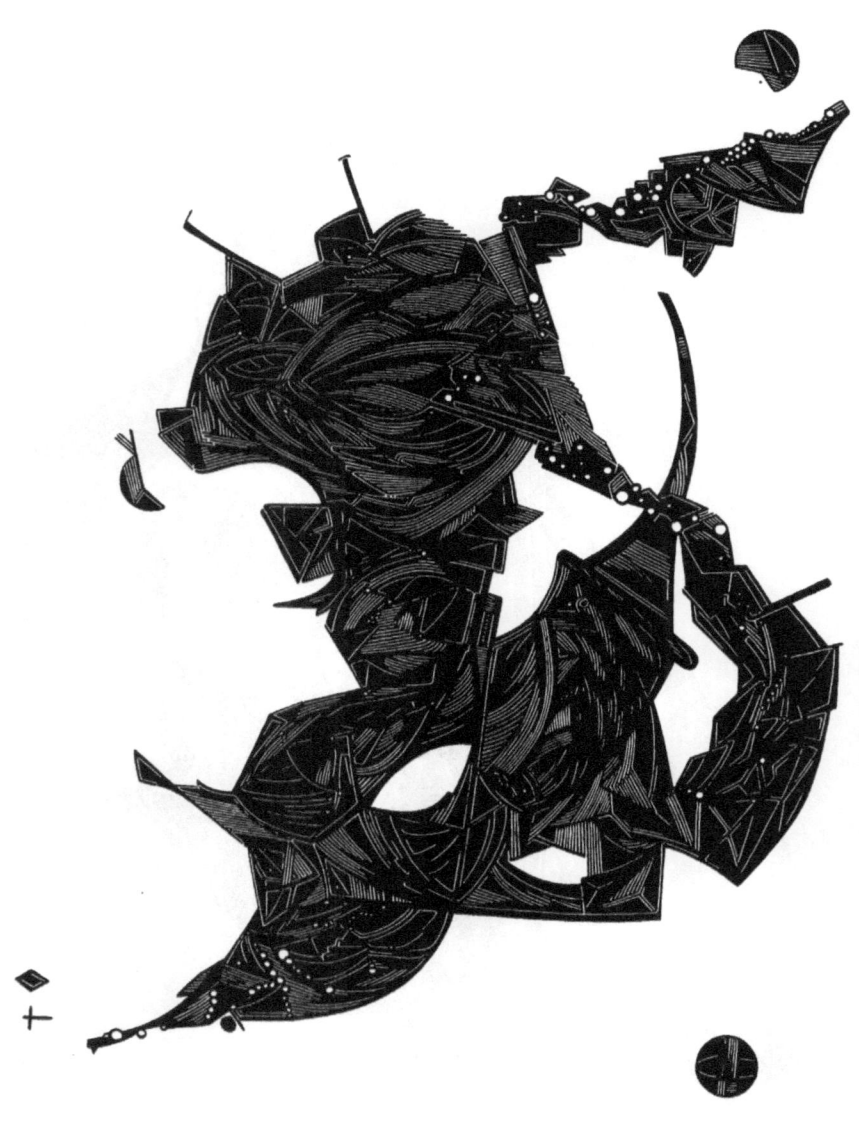

time is like a dime

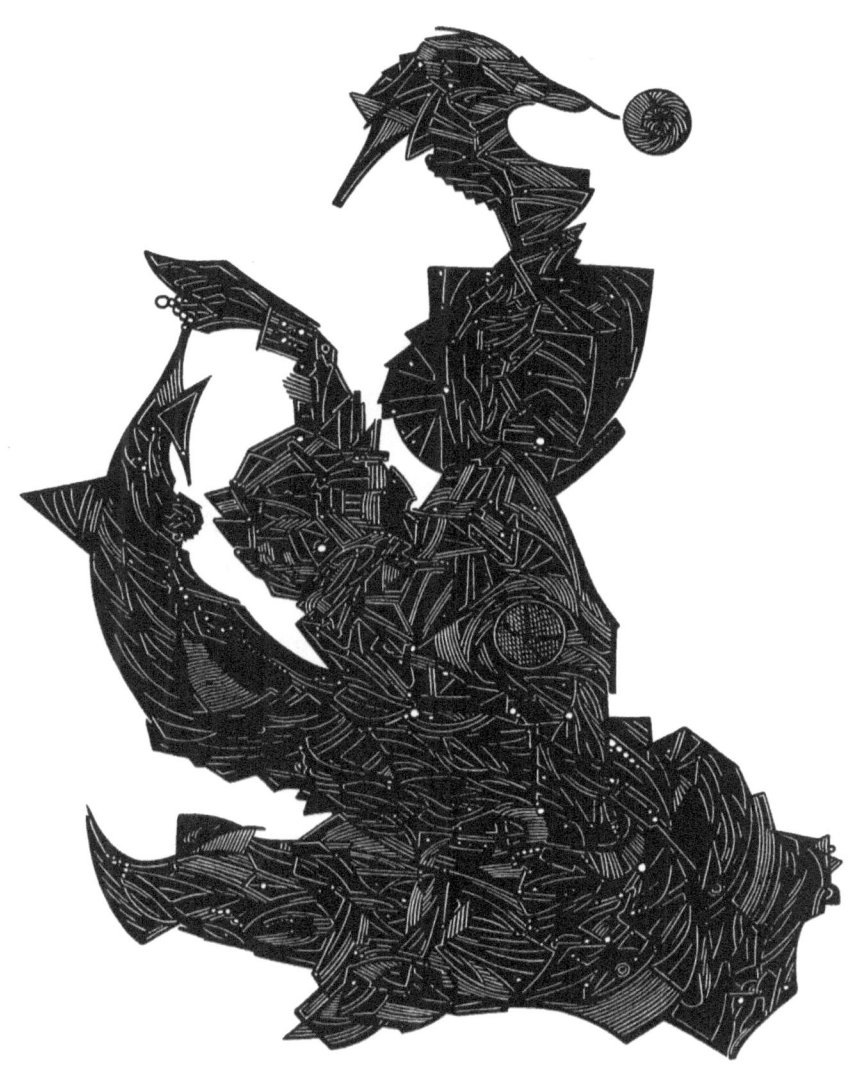

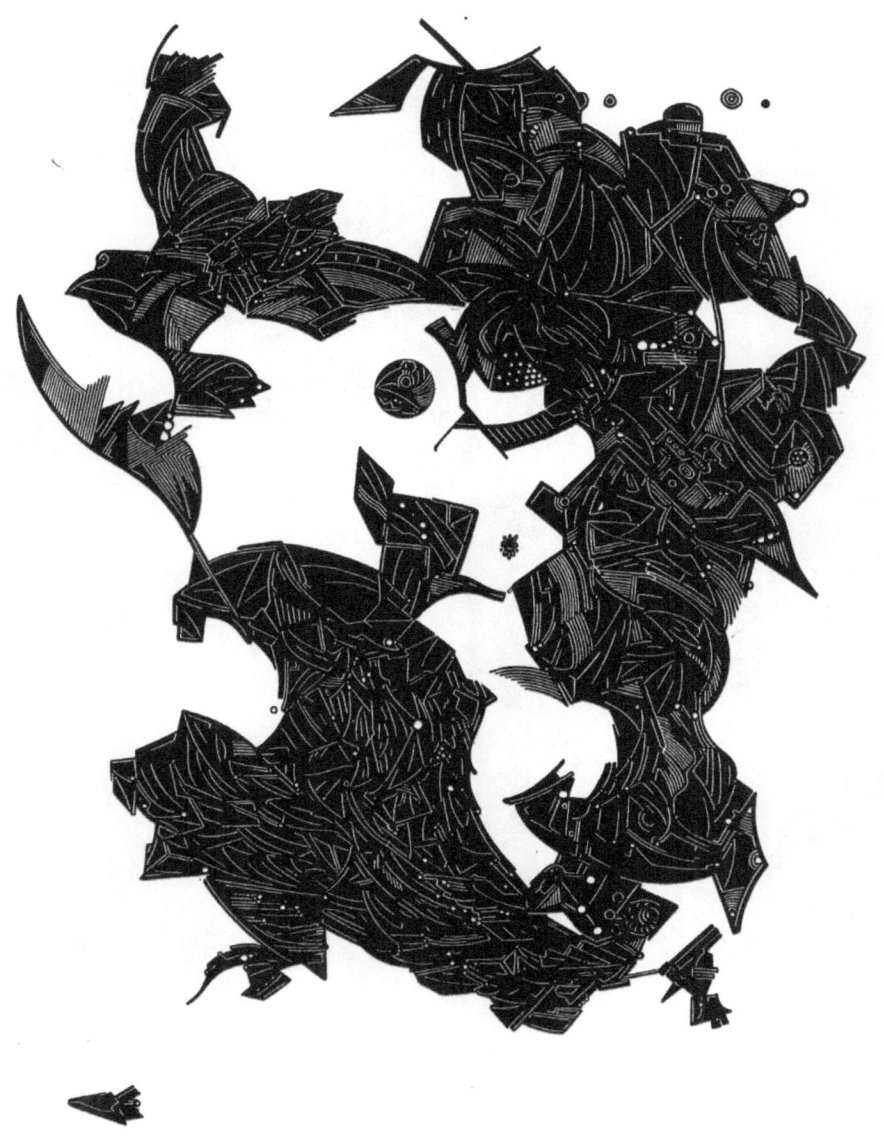

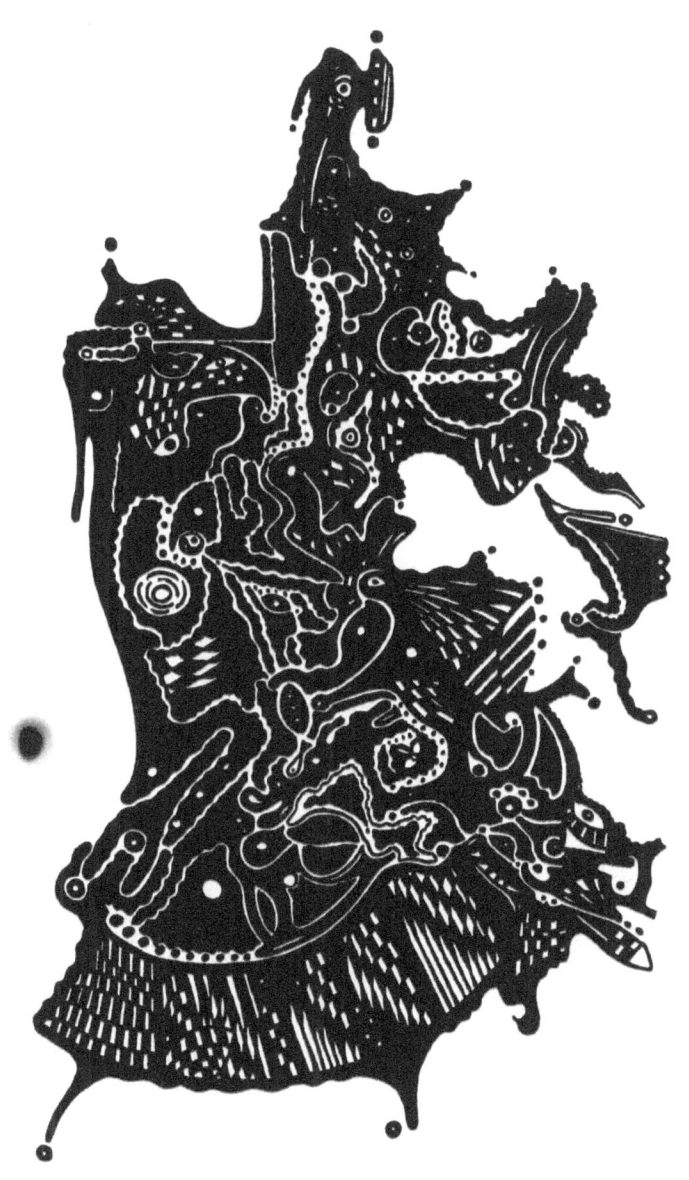

scan through toast

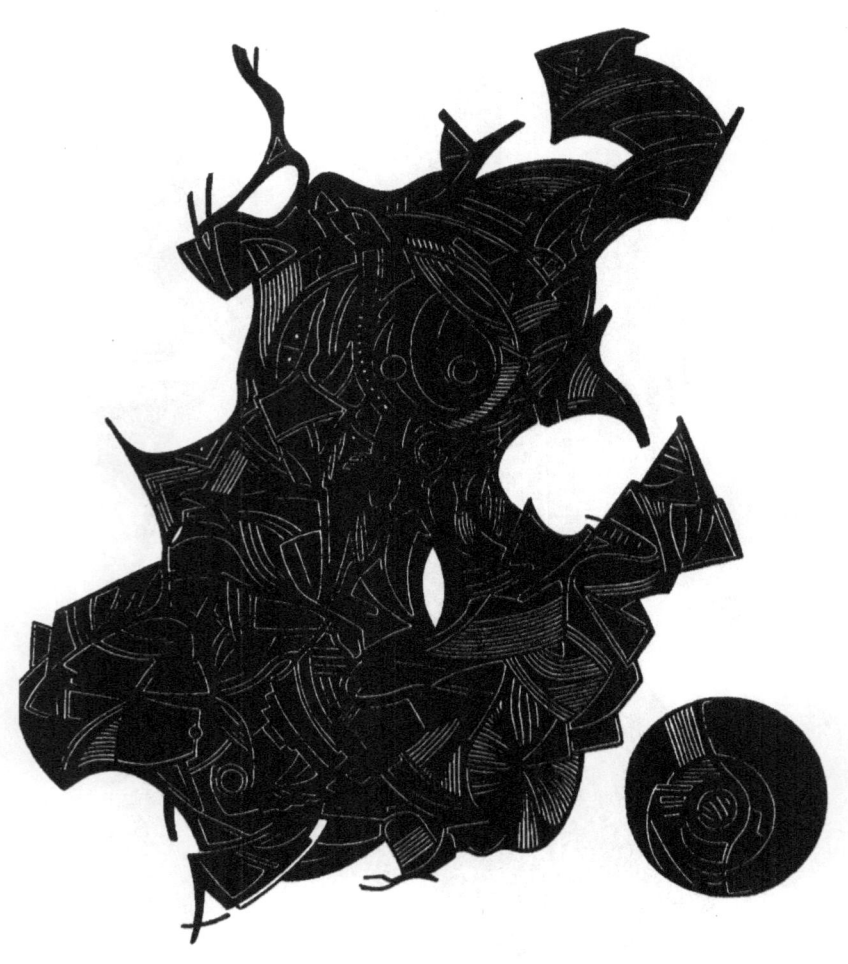

my point is light

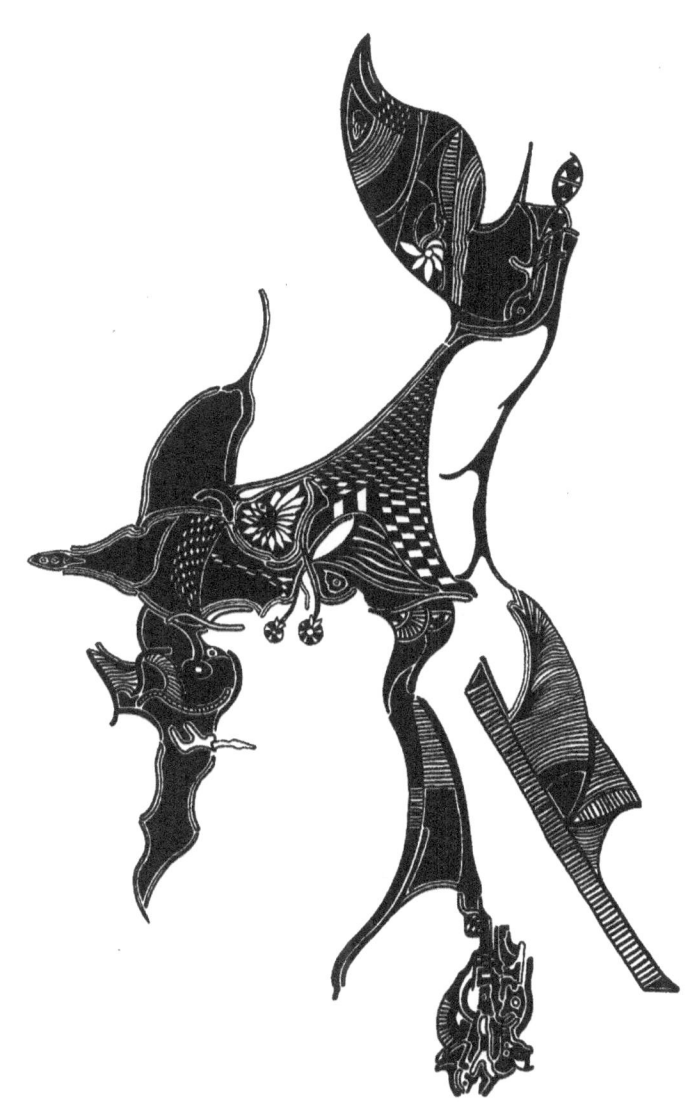

men use lemons to smoke outta

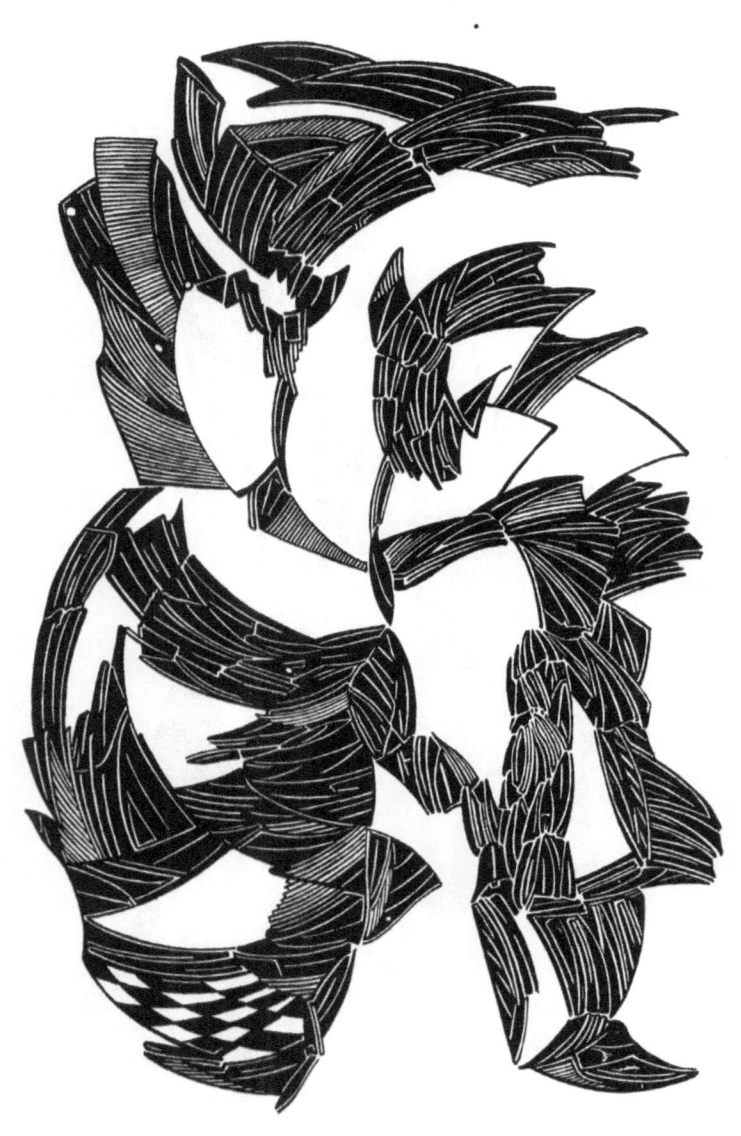

jealou@

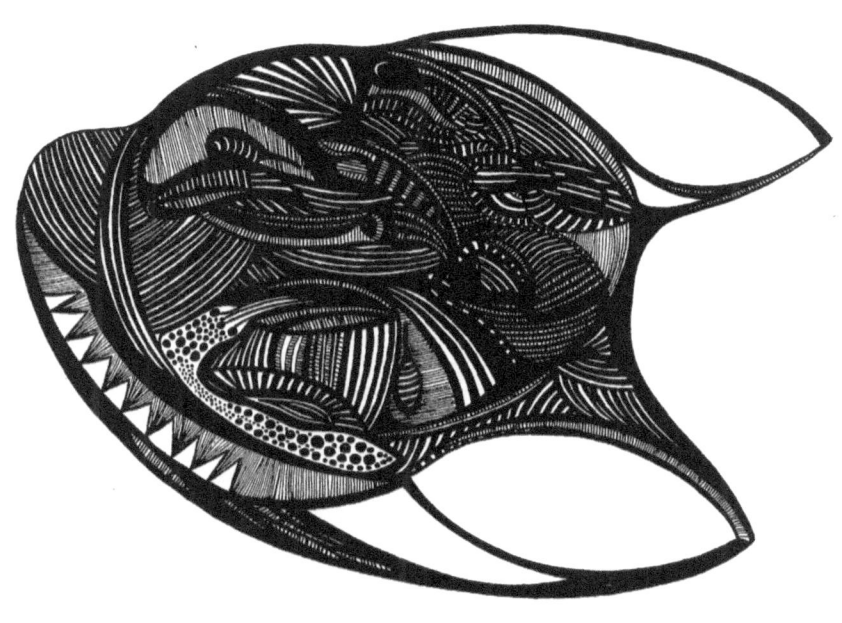

big picture

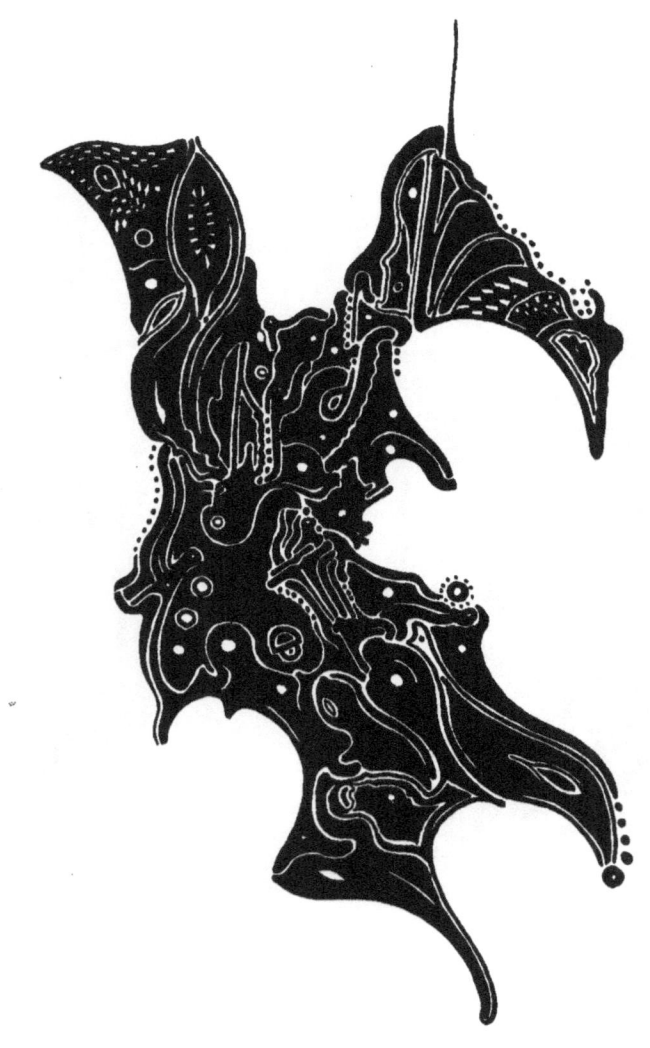

clairvoyance

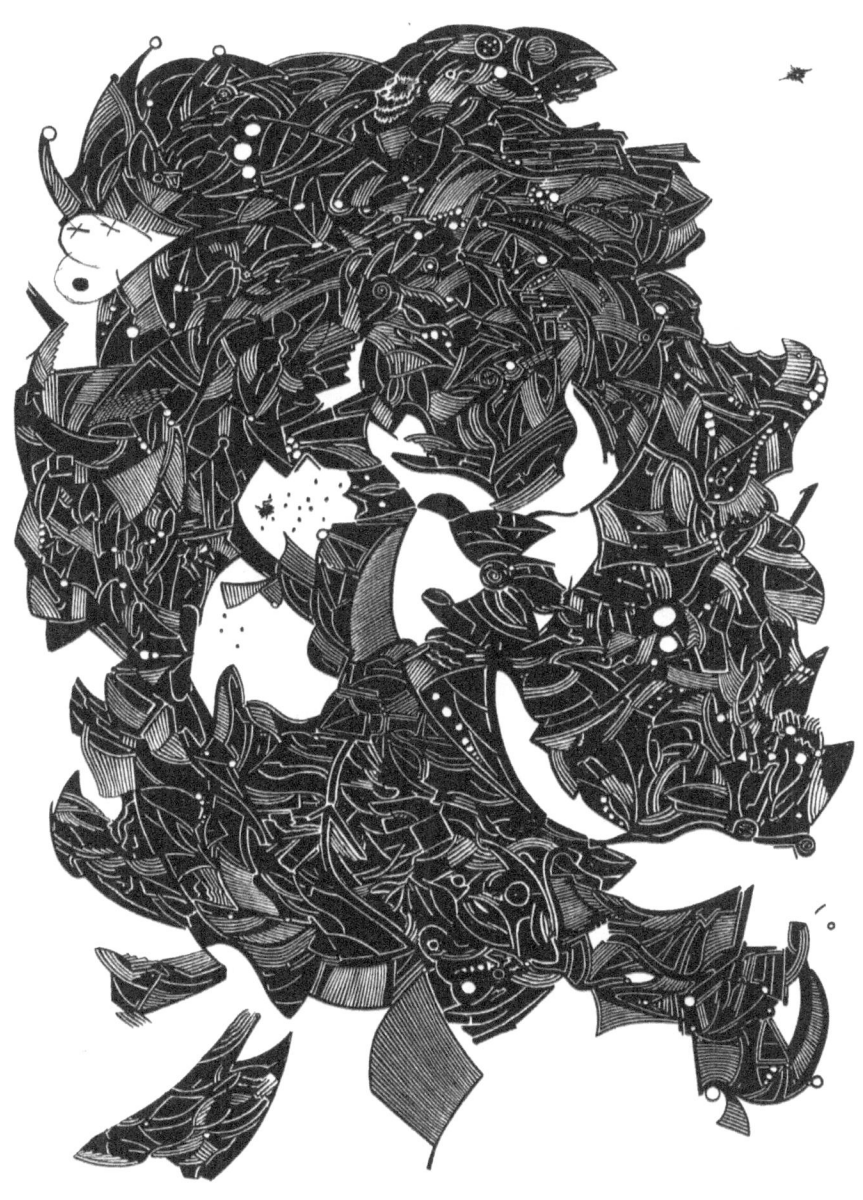

my heart is heavy

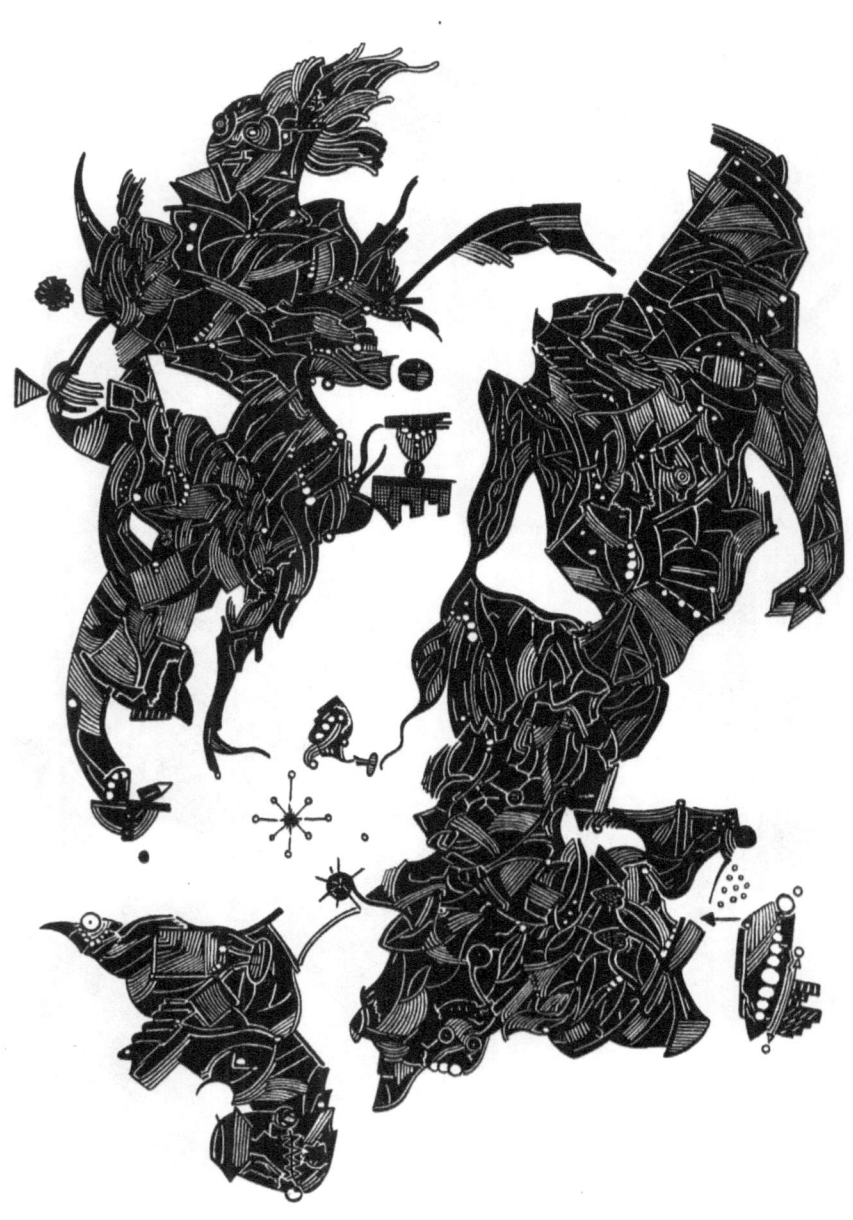

my head is steady

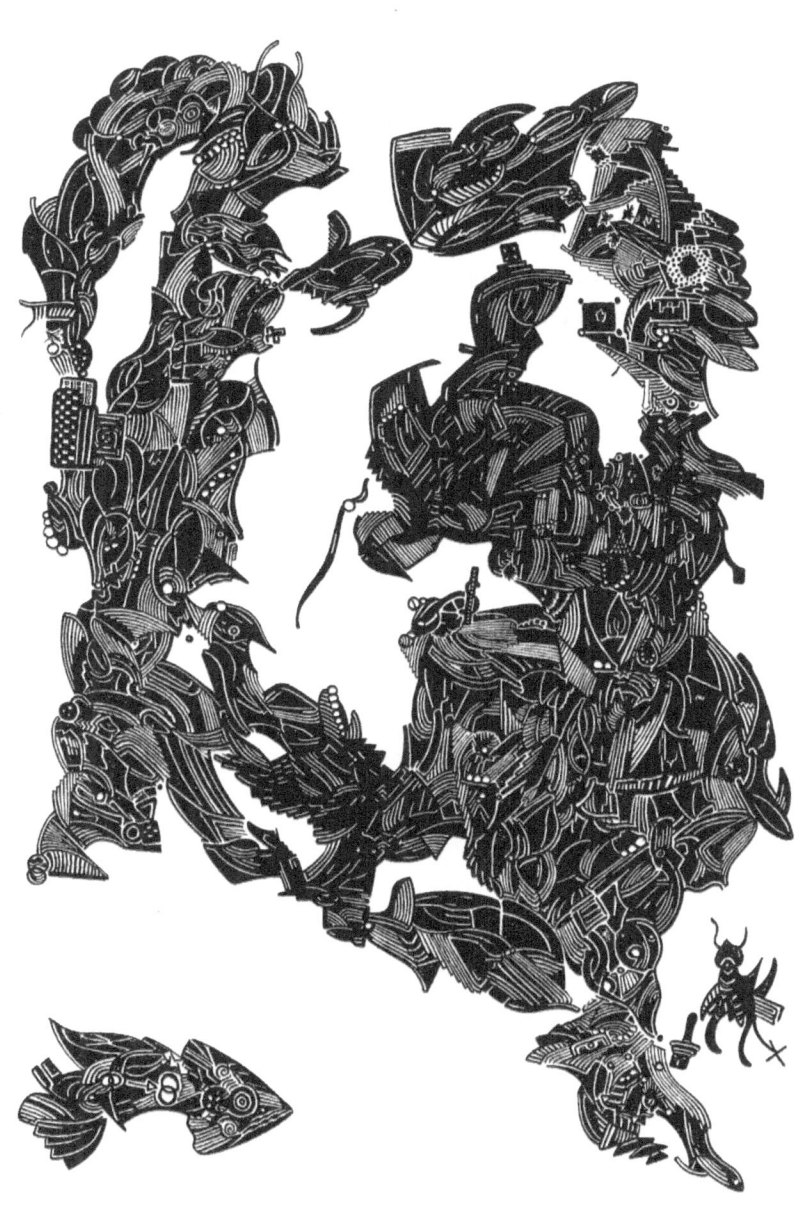

my ears are ready

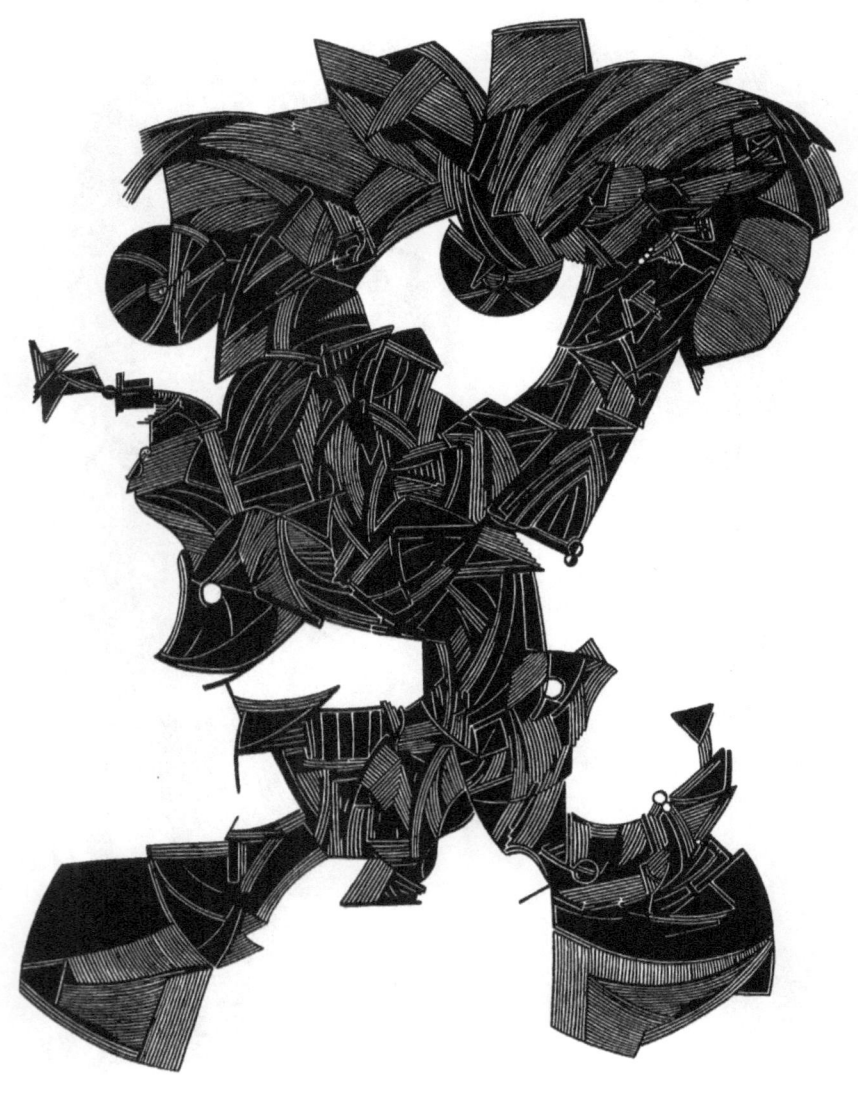

parasite

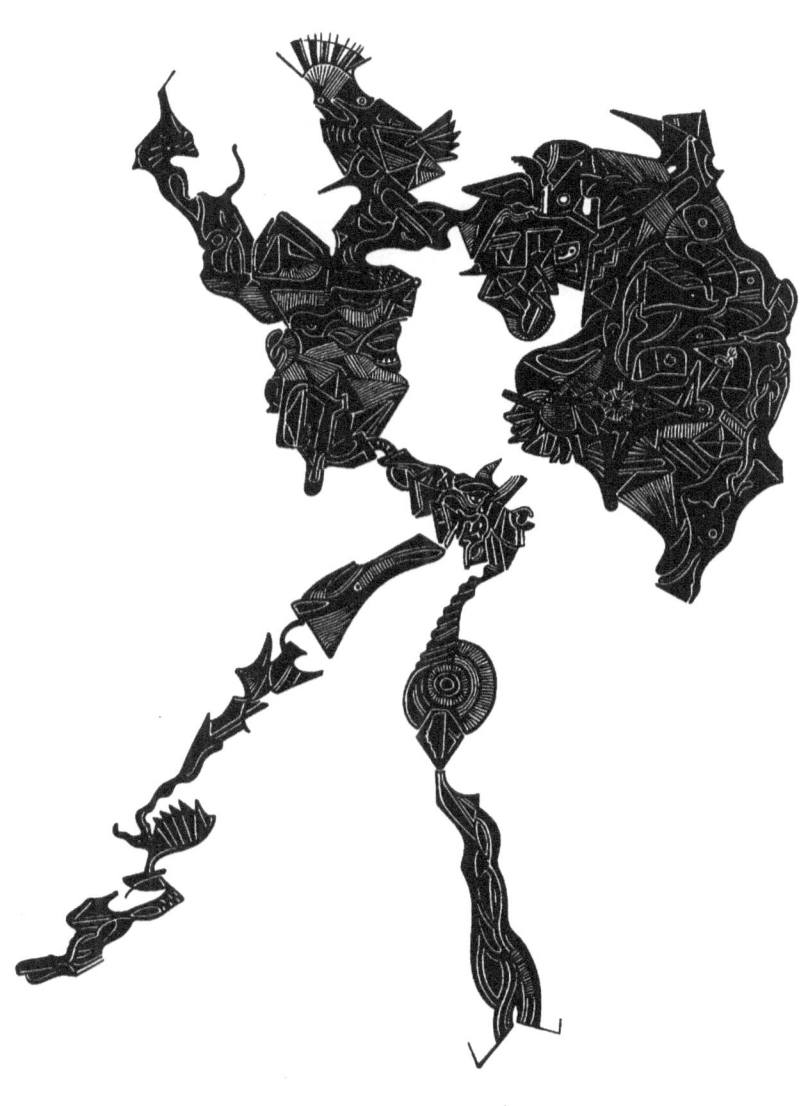

shake it out

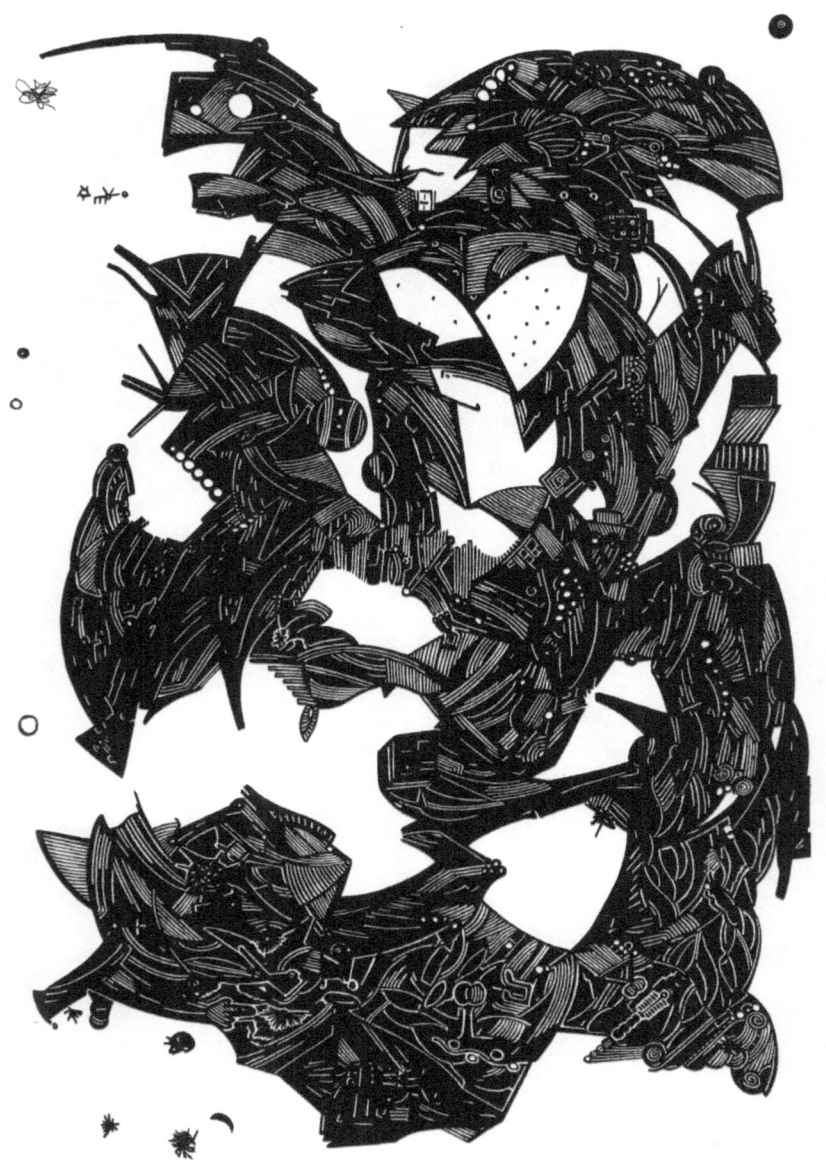

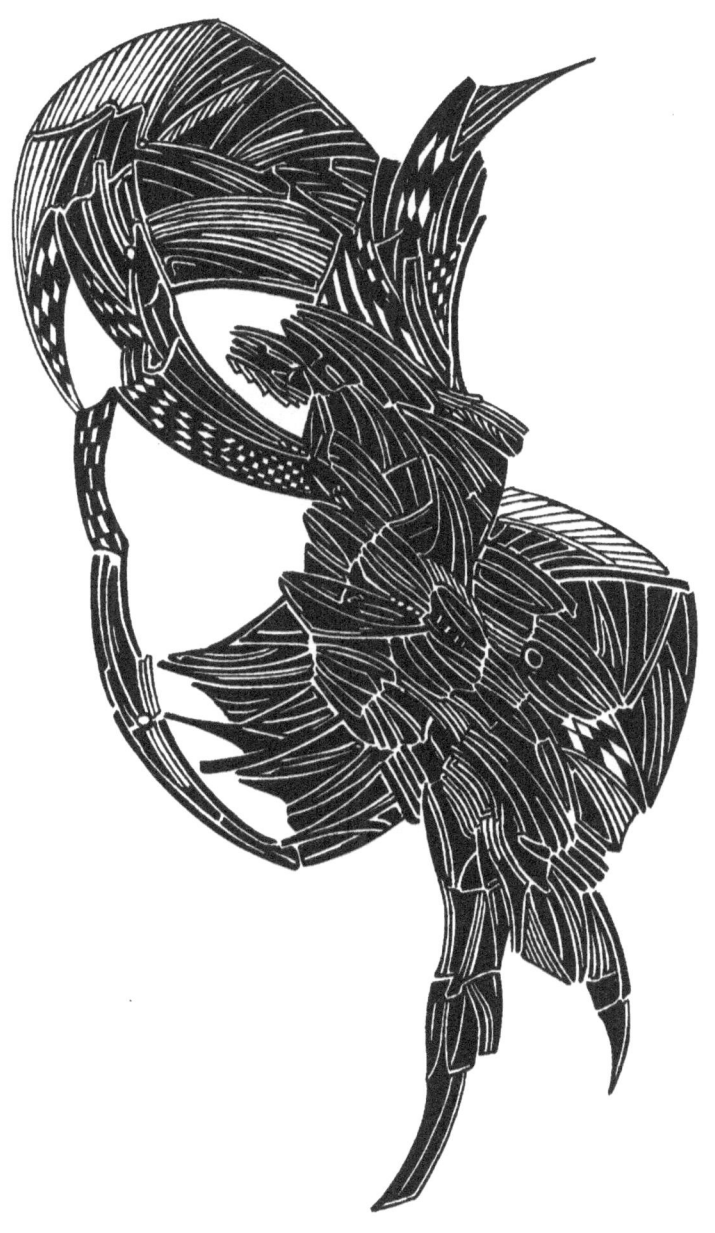

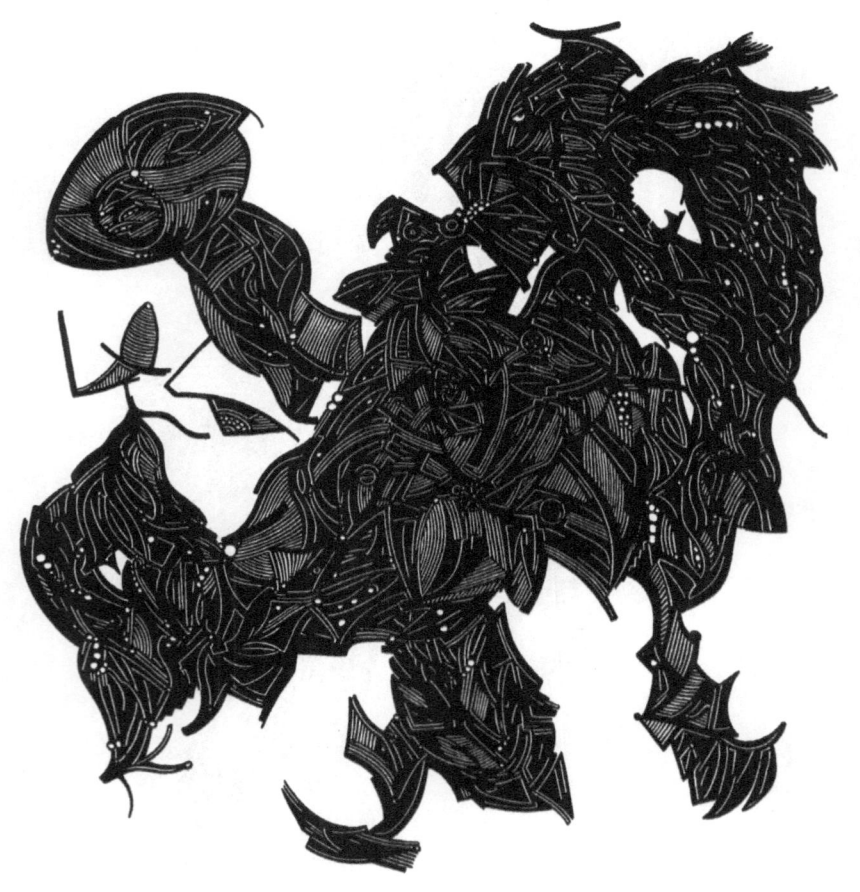

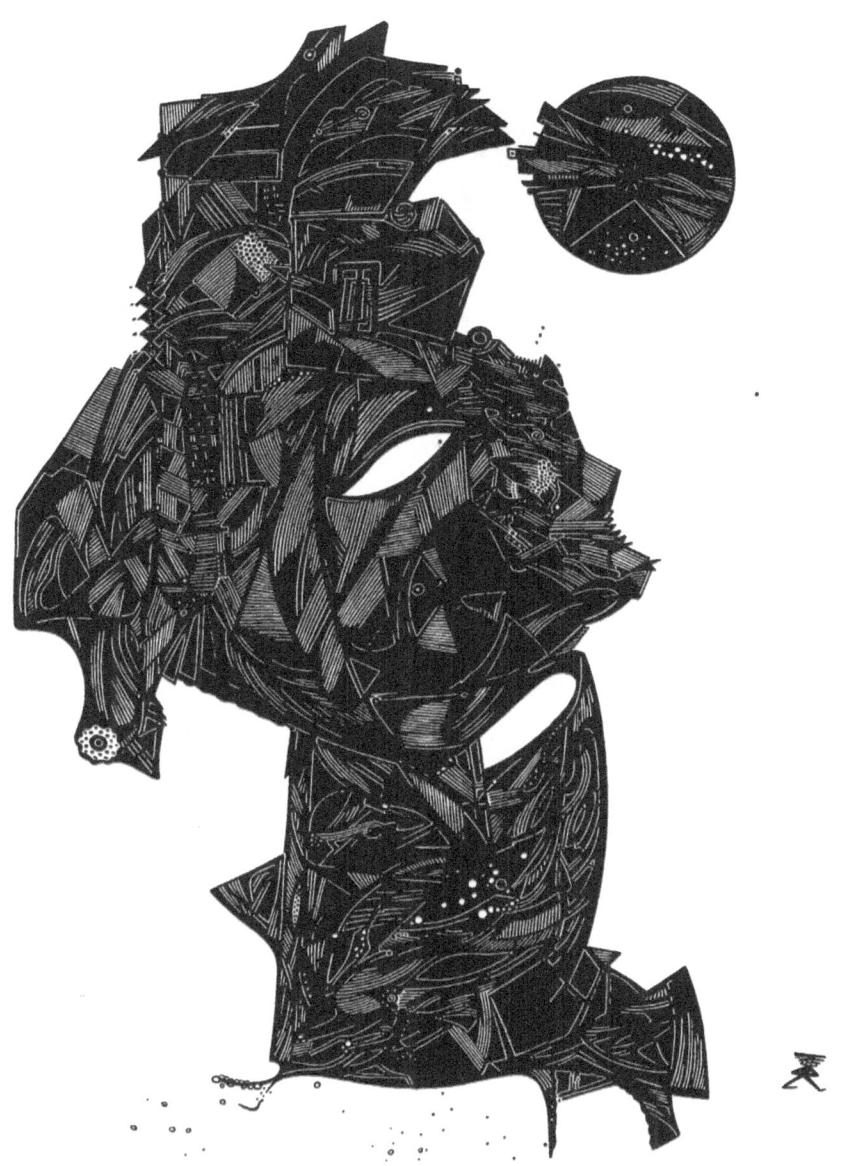

if you listen, they will guide you

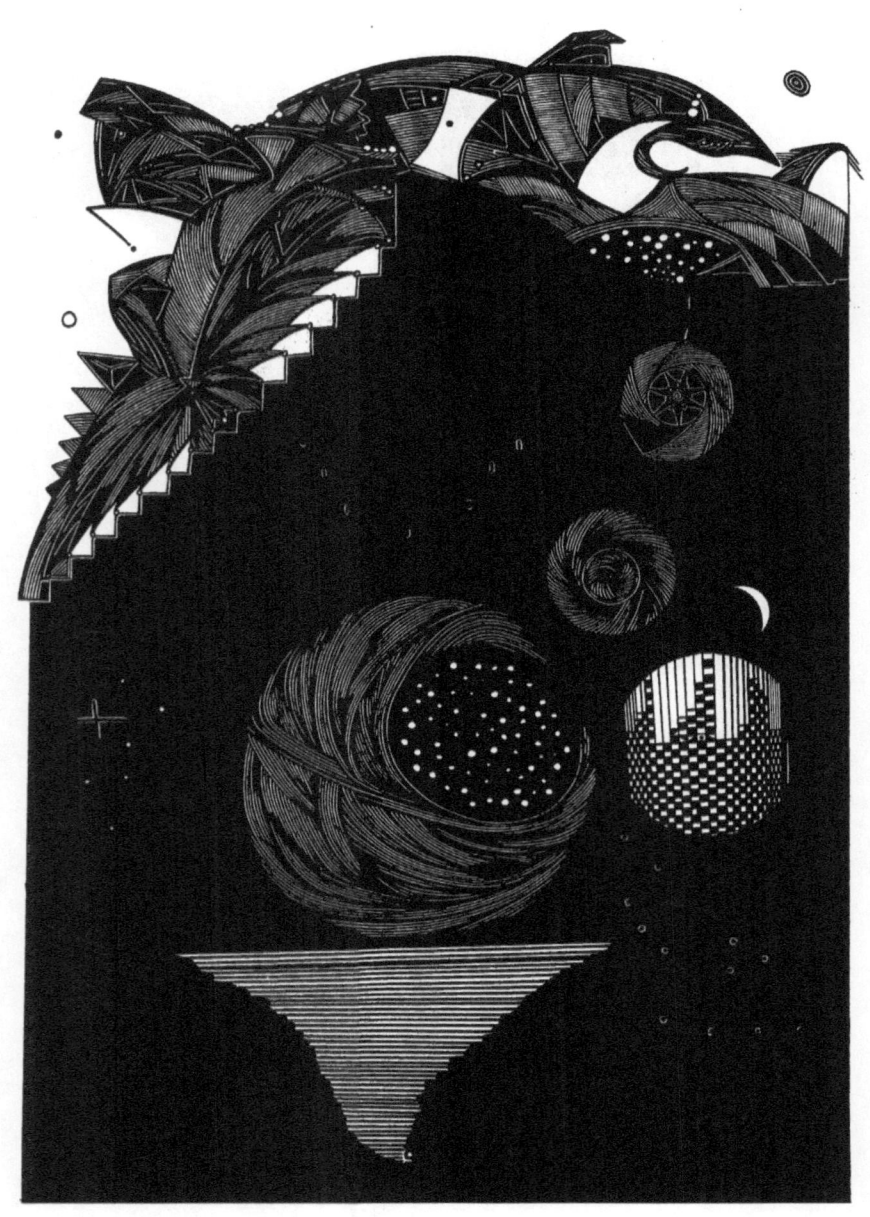

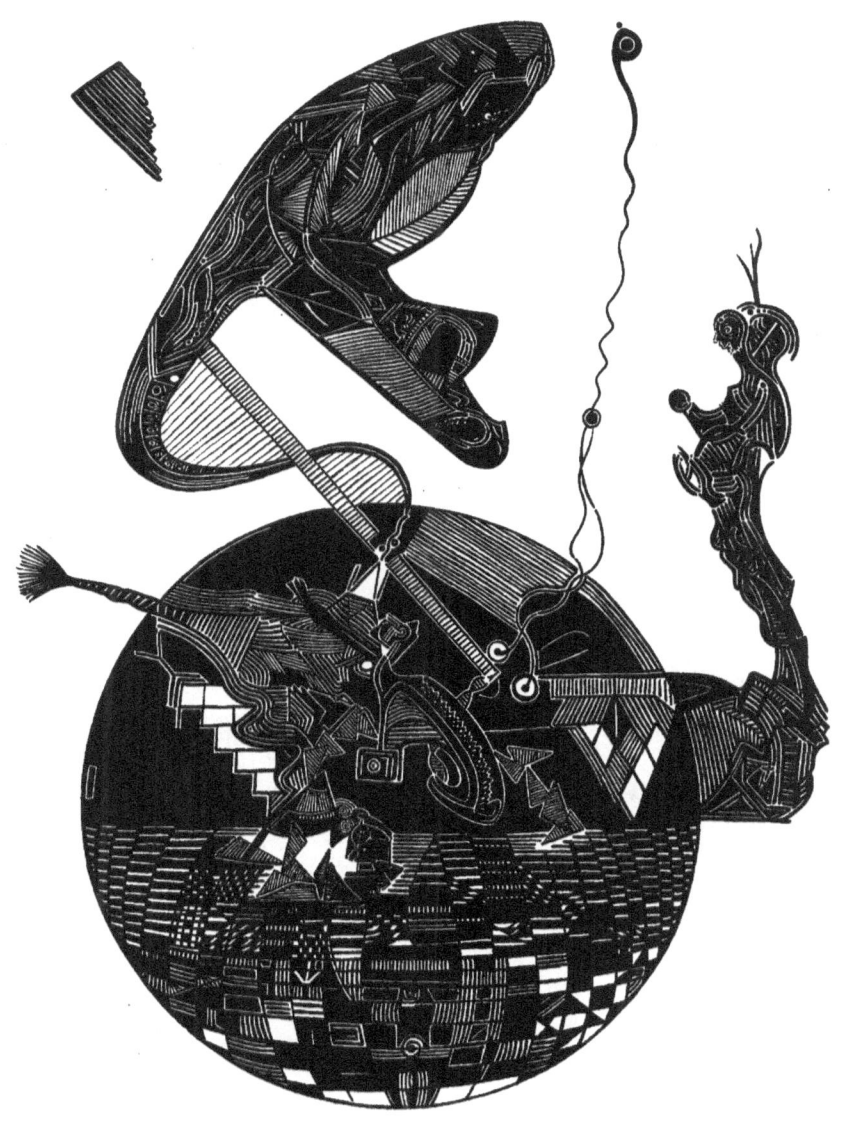

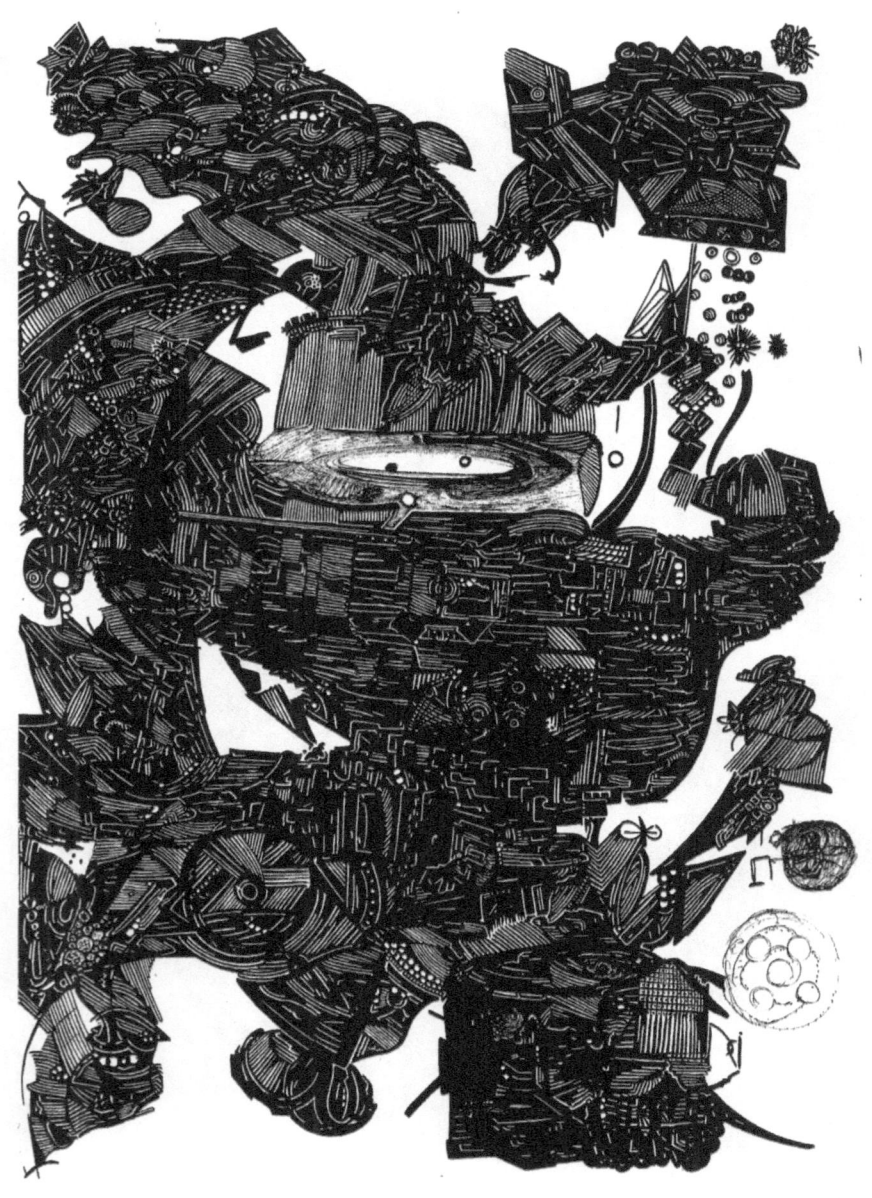

www.ingramcontent.com/pod-product-compliance
Lightning Source LLC
Chambersburg PA
CBHW031503210526
45463CB00003B/1056